Great Drawing Step-by-Step

THE PRACTICAL GUIDE TO
DRAWING ANIMALS

PETER GRAY

rosen publishing's
rosen
central

NEW YORK

Published in 2013 by The Rosen Publishing Group, Inc.
29 East 21st Street, New York, NY 10010

Illustrations: Peter Gray
Editor: Ella Fern
U.S. Editor: Kathy Campbell
Design: Graham Rich
Cover Design: Peter Ridley

Library of Congress Cataloging-in-Publication Data

Gray, Peter, 1969-
The practical guide to drawing animals / Peter Gray. -- First [edition].
 pages cm -- (Great drawing step-by-step)
Includes bibliographical references and index.
ISBN 978-1-4488-7216-9 (library binding)
1. Animals in art. 2. Drawing--Technique. I. Title.
NC780.G69 2012
743.6--dc23
 2011052039

Manufactured in China

SL002236US

CPSIA Compliance Information: Batch #S12YA: For further information, contact Rosen Publishing, New York, New York, at 1-800-237-9932.

Contents

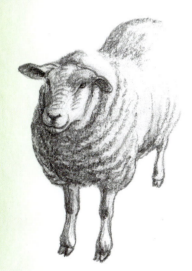

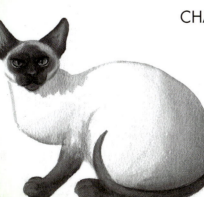

Introduction

When prehistoric man first took a burned stick and drew on the wall of his cave, it was animals that he chose to depict. To this day, the animal kingdom continues to fascinate and inspire us to create art. The subject is vast and almost unbelievably varied, offering the artist new interests and challenges at every turn.

This book aims to instruct the reader in the fundamental skills of drawing animals so that, with some application, even the complete beginner should be able to produce satisfying results. It is designed as a course, with each new subject following naturally from the previous one. Step-by-step demonstrations will teach you to capture basic animal form and then gradually increase your facilities to render shade, texture and detail. We will investigate various materials and techniques and strive to develop your own expressive drawing style along the way.

Capture expression and personality in your subjects.

Learn techniques for sketching animals from life.

Convey textures with elegance and simplicity.

Work up your drawings
into expressive and
dramatic statements.

Unlike the disciplines of still life, landscape and portraiture, animals can be elusive, unpredictable and rarely keep still. For these reasons, I recommend using photographic reference for most of the exercises in this book. But there is much more to drawing than merely copying from pictures. Photographs are merely starting points: selection, simplification, mark making and self-expression will make pictures that are more than mere copies. When following the exercises, try to resist simply copying my examples; apply the same stages to photographs of your own or in books, to create new pictures.

As you grow in confidence, I'll discuss strategies for working directly from life, for bringing drama and character to your pictures and for developing your own creative flourishes. The 200 or so illustrations in this book represent only a tiny fraction of the techniques and stylistic approaches open to you as you continue to develop your mastery of drawing animals.

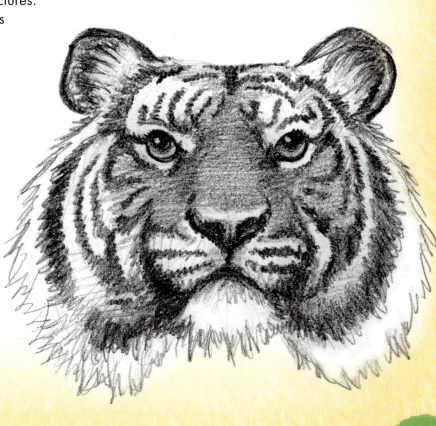

Draw with bold and
confident mark making.

Body Structure

In spite of the variety found in the animal kingdom, you'll be pleased to know that the basic underlying structure is the same for most of the creatures on the planet. And what's more, it's the same as our own!

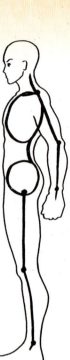

Compare the human figure with that of other primates such as the chimpanzee. The joints are the same, but there are a couple of important differences. Because apes mainly walk on all fours, the pelvis is proportionately much smaller than ours. The spine does not curve in at the back like ours.

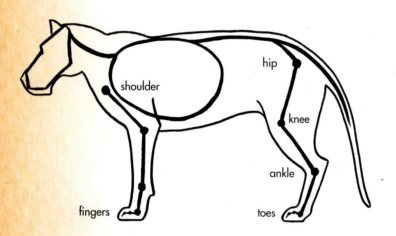

Other quadrupeds have the same curvature of spine and small pelvises as apes. Differently developed feet at first make the diagram of their joints look unlike ours, but looking at the lion above, you can see that in fact the pads of its paws are equivalent to the fingers and toes of the primate. It walks on what are the balls of the feet and hands in primates. The shoulder and hip joints are very close to the body and are not so immediately visible as in primates.

Birds both large and small are similarly constructed. It is not so easy to discern the joints in a bird's wing, but each joint plays an important function that is useful to understand when drawing birds, especially when the wings are unfolded.

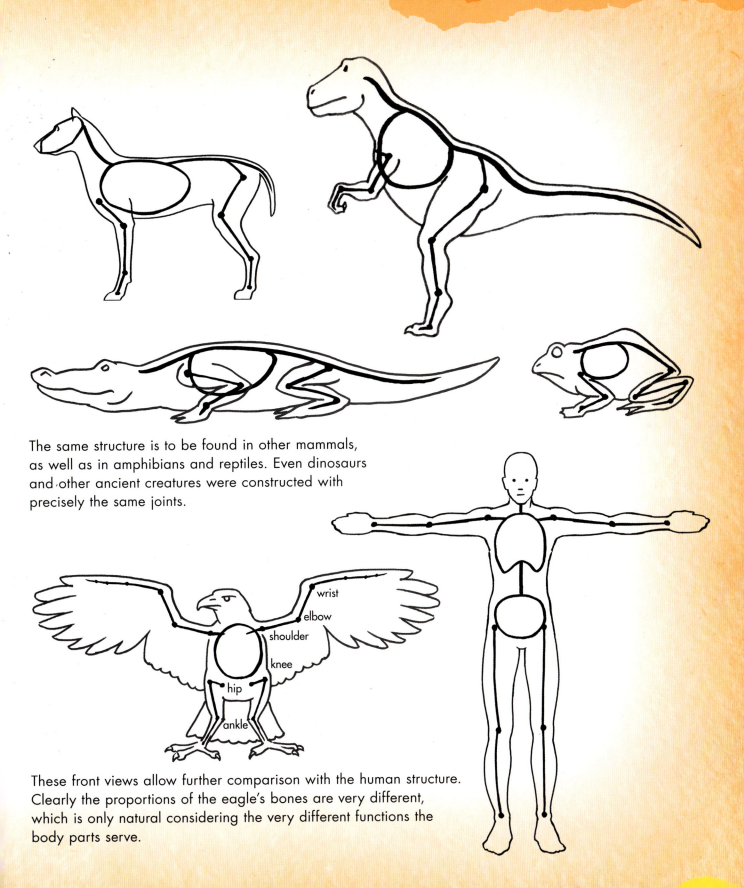

The same structure is to be found in other mammals, as well as in amphibians and reptiles. Even dinosaurs and other ancient creatures were constructed with precisely the same joints.

wrist
elbow
shoulder
knee
hip
ankle

These front views allow further comparison with the human structure. Clearly the proportions of the eagle's bones are very different, which is only natural considering the very different functions the body parts serve.

Basic Materials and Equipment

One of the great things about taking up drawing is that you need very little equipment to get started. There is a large and highly profitable industry in artists' materials and some of the elaborate items on show in art shops can be very tempting, but fancy media and equipment generally do little to improve your skills and can confuse the issue of learning to draw. To start with you'll need pencils, paper, an eraser and a knife, but throughout the book we'll look at other materials and tools you might want to experiment with and add to your kit.

Pencils
Although any pencil will do for mastering the basics of drawing, cheap ones can be scratchy and unsatisfying to work with. It's well worth spending money on a few good-quality pencils from an art supplies shop. They are graded from H (hard) to B (black) with a number prefix indicating the degree of hardness or blackness. A useful starting set would be H, HB, 2B and 6B.

Supports
Many of the exercises in this book can be undertaken on the tabletop, but for your comfort you may prefer to tilt the drawing surface toward you. Sketchpads usually have a back cover rigid enough that you can lean them against the edge of the table. For working on loose paper, a small drawing board may be useful. A thin sheet of plywood, say 1/4 inch (5 mm) will be strong enough to carry with you for working on location. Make sure it is sanded smooth and slightly larger than your paper, which can be affixed with masking tape at the corners.

Eraser
An eraser is a vital part of your kit. There is absolutely no shame in erasing mistakes and rough guidelines — they are an important part of the drawing process.

Buy a good-quality eraser that is neither too hard nor too spongy; there are dozens of varieties on the market, but they all do essentially the same job. When the corners wear blunt, an eraser can be trimmed with a knife to produce a fine working edge. For detailed erasing I often use a special eraser that comes in the form of a pencil and can be sharpened to a point.

HANDY HINT
Buy pencils of different grades with different colored shafts so that you can identify them at a glance.

Paper

For your early sketches, virtually any paper will do. A cheap spiral-bound sketchpad, A4 or preferably A3, would be good, but photocopy paper or even scrap paper will be fine. Expensive paper only serves to inhibit your freedom to make mistakes.

As you advance in skill and ambition, the more important the grade and type of paper becomes: chalks and charcoal work best on a lightly textured surface and some subjects might call for the paper to be toned (see pages 28–9). Wet media, such as watercolor, need thicker paper that won't buckle with moisture (see pages 26–7). Paper rated anywhere between 120 lbs (200g/m2) and 180 lbs (300g/m2) should be quite stiff enough. For larger drawings, you could use decorators' lining paper, which is very cheap, robust and comes on rolls of ten meters. You may also enjoy experimenting with shiny paper, brown parcel paper or even cardboard.

Sharpening

A sharp knife or scalpel is essential for fashioning the points of your pencils. For drawing, pencils are ideally sharpened to reveal a good length of lead, unlike the uniform point produced by a pencil sharpener. Keep the blade at an acute angle to the pencil, and always sharpen the pencil away from your body. Soft pencils such as 2B or 6B require regular sharpening, maybe several times in the course of drawing a single picture. A pencil sharpener can be handy for repeatedly honing a point for detailed work.

HANDY HINT

Some pencil sharpeners come within a capsule that collects the shavings. These help you to avoid littering when you're drawing on location.

Drawing Basic Form

The most important aspect of drawing any animal is to capture its essential shape or "form"; no amount of detail can save a drawing that is badly proportioned. So it is well worth spending some time on this simple exercise to gain practice in observing and drawing the weird and wonderful forms found in the animal kingdom.

Find photographs of various animals shown from simple angles, such as profiles. Use only an HB (or softer) pencil and a wad of scrap paper. Before starting each drawing, look carefully at the photograph and mentally dissect it into the circles, ovals and curves that make up its form. Forget what you might know about animals, just look at each creature as a set of abstract shapes and draw them very quickly. Then it should be quite easy to complete the outlines and add some details here and there. Do lots of these little drawings and spend no more than five minutes on each.

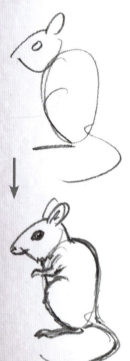

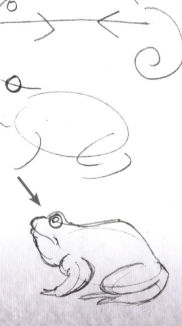

HANDY HINT

You may find it easier to identify the basic forms of familiar animals by turning the photographs upside down. This helps to override any fixed ideas, so you can see the form like new.

10

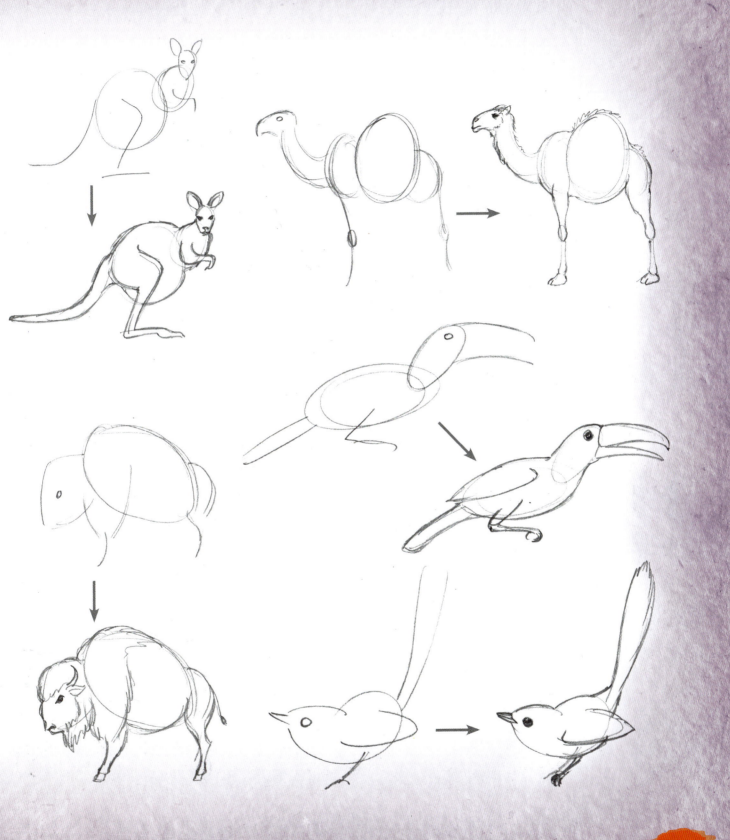

Drawing Basic Form

When the aim is to make a more finished drawing, the same loose approach to form can be taken. Staying with an easy profile view for now, I have drawn a horse in steps, with attention to correct proportions and finer detail. To follow these steps, find a good photograph to use as your source. Make sure that the details are unobscured, and the quality of light makes the contours of the animal clear enough to add shading later.

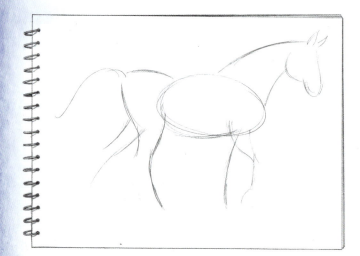

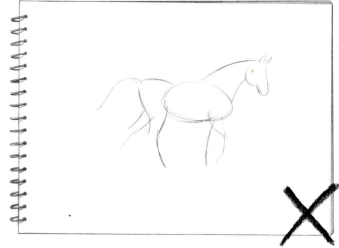

Step 1 correct

Having chosen a suitable picture, I studied it and mentally broke down its form into rough shapes. Before sketching them in, I rehearsed the rough shapes with the pencil hovering above the paper. I tried to fill the page as fully as possible without the drawing going off the edges.

Step 1 wrong

Be careful not to make your drawing too small. Working small restricts your movements and tends to produce fussy pictures. Aim for a bold drawing right from the start.

Step 2

Happy with the rough shape, I smoothed out the horse's outline and gave the legs some width and form, all the while looking at the photograph. As you do this, don't let yourself get sidetracked by any detail.

Step 3

Next I refined the head and neck so that I had a definite measurement by which to check the length of the legs. I did more work on the overall length of the legs and the positions of their joints, which I marked as oval shapes.

Step 4

It's all too easy to draw animals' legs as weak and shapeless. Drawing the joints first as sizeable masses helps in the construction of the legs' contours. At this stage, I finalized the outline of the whole drawing and also marked the shape of the mane and tail.

Now the guidelines can be erased, ready for shading. Turn to page 16 for various ways to render your line drawing.

HANDY HINT

Conveniently, horses are roughly three heads tall at the shoulder and the same length in the body, though your chosen example may differ slightly from this generalization.

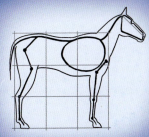

Checks and Measures

Correct proportions are an important aspect of good draftsmanship, especially when drawing animals. Some simple techniques can be very helpful for spotting errors and getting your drawings off to a good start.

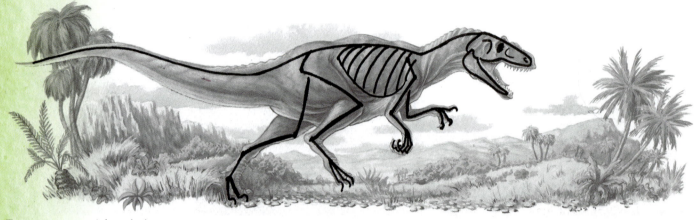

Try to imagine the skeleton inside your subjects. You could even sketch it on your drawing. This helps you to get a sense of the animal's articulation and to check that limbs are consistently proportioned.

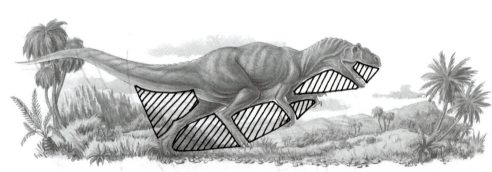

It can also be helpful to observe the "negative shapes," the spaces in between body parts.

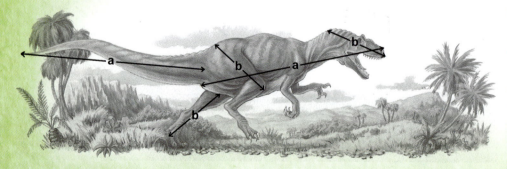

Regardless of the size of your drawing, you can keep a check on proportions by simple measuring. With a pencil or ruler, identify similar dimensions on your source image and check that the equivalent parts of your drawing are consistently proportioned.

If the size or placement of the drawing on your paper means that you have too little space for some features, let them run off the edge of the page. Do not squash the proportions to fit the page.

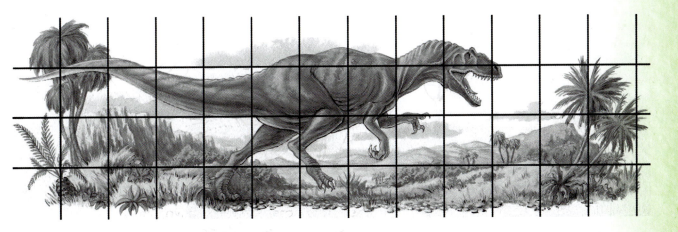

If all else fails, you can be sure of a good start by "squaring up." Draw a regular grid on tracing paper and place it over your source image, then draw a similar grid to fit on your drawing paper. Then the picture is broken down into easily observable chunks, which may be drawn individually. This is how the Old Masters enlarged their drawings for murals.

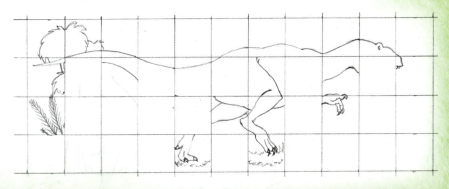

15

Pencil Rendering

Applying shading, or tone, to your pictures is known as rendering (or sometimes modeling). Use a soft pencil (2B–6B) and try not to be too timid. Errors can easily be erased. Work over the whole drawing, refining detail as you progress. To avoid muddy pictures, it's often a good idea to play down the markings or coloring ("local tones") of your subject and render only according to the fall of light on your subject, leaving lots of bare white paper.

Restricting the shading to a single direction can produce an accomplished finish, though it may take time to master. This style tends to require a lot of erasing around the edges afterward.

This style of shading is perhaps the easiest to master, done in random directions with no attempt to disguise the pencil marks. It is not the subtlest approach, but it is energetic and effective.

HANDY HINT

Squinting your eyes is a great way to judge tone on your subjects and spot inconsistencies in your drawings.

The shading here follows the form, curving around the body like the contours of a map. This is difficult to achieve, but can be quite effective in helping to describe solidity.

16

Perhaps you don't want your pencil marks to be visible at all. This picture was shaded with the side of the pencil and the tones built up in painstaking layers and blended with a fingertip. The effect is much softer.

Pencil grips

Holding a pencil in your writing grip allows you control of small movements from the fingers. But for drawing, most movements will be made from the wrist, elbow and shoulder. Different grips will free your pencil to make a full range of strokes, with that all-important element of confidence.

With the blunt end of the pencil tucked into the palm, this grip is good for bold, angular mark making and heavy shading.

This is a general-purpose grip that is especially good for mapping out faint underdrawing and for long sweeping curves. The pencil is held loosely about halfway along its shaft, allowing for varied pressure.

Much like a typical writing grip but with the pencil more upright, this grip is good for fine detailed work or for drawing in a small sketchbook.

Held at the tips of the fingers and thumb, the pencil can produce very subtle lines and shading.

Mark Making

The more you handle the pencil, the better you will appreciate its range of expressive marks. Well-considered mark making brings texture and character to animal drawings and allows you to convey your subjects' features with economy and ease.

A harsh, angular outline brings out the taut muscularity of the hunting dog.

Graceful lines and minimal shading help to describe the sleekness of this fawn. A hint of texture along its back adds to the feeling of softness.

The fur here is more heavily modeled with strong flowing lines that follow the direction of hair growth. The crisper outline of the face contrasts with the chaotic mane.

This deceptively simple rendering relies on the direction and quality of the marks. It's really only a study of the tiger's markings in heavy pencil with a basic mid-tone shaded in places and some rough, hairy outlining.

I used a sharp, hard pencil (HB) for this study that concentrates on the elephant's wrinkles.

I used the side of a soft pencil to mimic the texture of this sheep's fleece, thrown into relief by low winter sunlight. Allowing the drawing to fade into the white of the paper, the viewer completes the outline in his mind's eye.

This hatching crocodile is all about scales, wrinkles and teeth, for which I had to produce the appropriate varied marks.

A range of marks was required for the various stages of plumage on this scruffy young parrot.

HANDY HINT

Strong drawings will usually result if you pay particular attention to a single aspect, such as lighting, markings, texture, muscularity or gracefulness.

New Viewpoints

Drawing profiles is good for practice and for increasing your familiarity with different animals and their proportions, but other viewpoints reveal more about a creature's build, articulation, character, behavior and so on. Working from photographs and breaking the subject down into abstract shapes, the process need be no more difficult.

An angle of view doesn't need to shift far from the profile to make a drawing more interesting. After drawing the initial shape of this frog, I sketched a guideline down the center of the back to help place features on either side of it. Then I carefully sketched the basic outlines before filling in the webbed feet and eyes in more detail. The shading helps to give the body more depth and solidity.

Again a carefully placed center line was invaluable for drawing the face of this flying squirrel. It also helped me in constructing the tail. In my rendering I have chosen to concentrate on the markings and local tone. I have kept the shading minimal, with just a touch here and there to convey a sense of solid form.

This rear view of a cat is a characterful pose that presents a rendering challenge. Lacking the distinct details of the limbs, it could easily end up as a formless blob. After the rough shapes were mapped out, I very carefully drew the center line so that it accurately traced the path of the spine. This helped me to analyze and draw the subtle curves of the body. In rendering the drawing, the light and shade aid the description of the cat's twisting contours and follow the direction of the fur.

HANDY HINT

Sketching from ornaments and toy animals gives you the chance to study them from every angle and gain experience of more complicated viewpoints.

21

More Materials

Different materials can enhance different qualities or add impact and visual interest to your work. Each medium has its own particular strengths and limitations. To find out what works best for you, give each a good workout on a varied range of subjects.

Pencil

For all its versatility and practicality, the pencil does not have the graphic impact or textural range of some other materials.

Graphite stick

This type of pencil is a thick stick of pure, soft graphite. It makes heavy marks and is a delight to draw with, though not ideally suited to small, light subjects like this piglet. Without a sharp point it's hard to be very precise, but it can be a vigorous graphic medium.

Charcoal

Charcoal, with its dark line, builds up tone very quickly, though it can be easily corrected or drawn into with an eraser. It is easily softened or blended with the tip of a finger.

Pastels

Pastels have similar qualities to charcoal, but they come in a vast range of colors and tones that can be mixed and blended with ease. Here I have used mid-gray and black with some strokes of white to lift the tone where necessary. Precision is difficult on small-scale drawings.

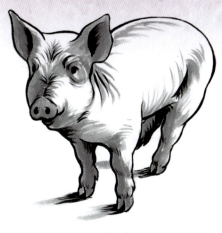

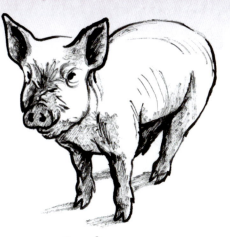

Felt-tip

Using ink requires you to make positive, confident marks. Felt-tips are not the subtlest medium and tend to convey a graphic quality that is more suitable for some subjects than others. The pens I have used here have a brush-shaped tip that makes for a pleasing, uneven line. I used black for the outline and gray for some rudimentary modeling.

Bamboo pen

An excellent tool to stop any timid tendencies is the bamboo pen. In effect it's a shaped stick, dipped into ink. When fully loaded, the line is thick and blobby. As the ink runs low, this pen produces interesting scratchy marks for shading or texture.

Dry Brush

This technique uses a stiff bristle brush, loaded with diluted watercolor or ink and then dabbed dry on a tissue. The marks then carry the texture of the bristles, making it useful for suggesting hair or fur. It's quite easy to build up sensitive tones. For this example, I switched to a fine watercolor brush to add detail.

Watercolor

Watercolor is an extremely sensitive and versatile medium that takes a lot of practice to master fully. I intentionally painted this example very quickly. I used very diluted black for the shading, softened at the edges with a tissue. Once dry, I used the same wash again to build up the tones in layers. Then I picked out some detail and outlining with a fine-tipped brush. Similar effects can be achieved with diluted ink or even coffee.

HANDY HINT

With different materials, your choice of paper may be important. Lightly textured paper provides a tooth for graphite and chalky materials to cling to. Felt-tips often work well on shinier paper. The more heavily you work, the more robust the paper needs to be – especially if you're working with washes.

Charcoal and Pastel Studies

When you have mastered the art of analyzing and drawing animal form you can approach the subject with sufficient confidence to make more loose and expressive drawings. Here are a couple of examples in charcoal and pastel, both done very quickly — about 20 minutes each.

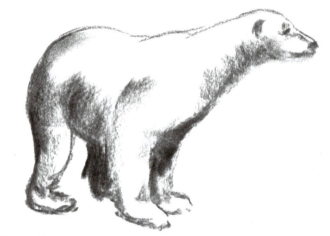

Step 1

If you're still a bit unsure of your animal drawing you could make an initial pencil drawing on scrap paper to establish a strong basic shape. Make the outline quite dark with a soft pencil.

Step 2

Place a fresh sheet of paper over your rough drawing and you should be able to see the outline clearly enough to trace it. Here I used the side of a short length of charcoal to depict the areas of shade. With the tip of the charcoal I then gently traced the outline of the bear's top edge.

HANDY HINT

Finished drawings in charcoal, chalks or pastels should be protected against smudging with an artist's fixative spray, although hair spray is nearly as good and much cheaper. You can also fix a picture at various stages while working on it.

Step 3

To sharpen up the drawing, I used a felt-tipped brush pen to define some of the more pronounced edges and to add some details to the face and feet. Try not to overwork the outlines and details, adding them only where more clarification is necessary. With the edge of a clean eraser, I carefully cleaned up a few stray charcoal marks.

24

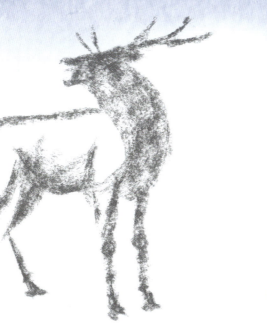

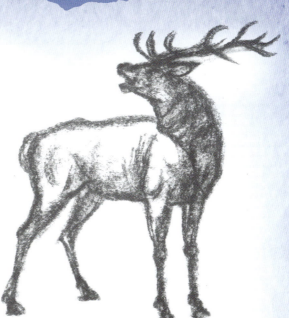

Step 1

I prefer to skip the pencil drawing and work directly in pastel. If it goes too badly wrong, I just start again. I used a mid-gray pastel here, again broken to a short stump and used on its side. As with the bear, I tried to convey shade and outline in a single motion, while setting down only the elementary form of the stag.

Step 2

With the end of the pastel, I then drew in more detail and strengthened the shading where necessary. All the while, I referred to the photographic source and corrected the form as I went along. I could happily have left the picture as a finished piece at this stage, but I thought that maybe I could bring out more character and solidity.

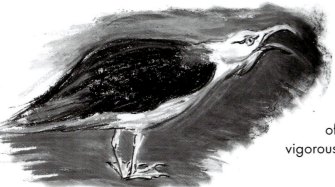

Pastels can also produce deep, rich tones and will stand heavy working over. This seagull study shows something of their potential for vigorous handling.

Step 3

I used the end of a charcoal stick to add a few details and embellishments. I also turned the charcoal on its side to deepen some areas of tone. I had to be very careful when erasing stray marks in order to avoid smudging the drawing.

Watercolor Studies

Watercolor or diluted ink present many possibilities for rendering your drawings. Here is a very simple example and another more heavily worked one. When using any wet medium remember to use a fairly heavy-grade paper.

Step 1

For this simple treatment, I started with the barest pencil guidelines. I wanted to let the brush do the drawing.

Step 2

With a medium watercolor brush and very diluted black watercolor, I refined the outline and filled in the broad masses of shade. Before the paint dried, I used a damp brush to soften the edges and blend the tones. I then used a darker wash to paint the markings. Once dried, I erased the pencil guidelines.

Step 3

I added selective detail here and there with a blacker mix and continued to soften the edges as I worked. A few tiny strokes of white ink brought out the highlights around the eyes.

HANDY HINT

If you're impatient for washes to dry, a hairdryer will speed things up greatly.

Step 1
I made this fairly detailed underdrawing based on two separate photographs. A few details of the ground help to unite the birds in a single setting.

Step 2
With black waterproof ink and a medium watercolor brush, I established firm outlines and the darker tones of the rendering. Much of the inking was done with the brush almost dry, to achieve a fluffy texture.

Step 3
After erasing my pencil marks, I used a couple of layers of diluted black watercolor to fill in broad areas of shade and further develop the texture. If I chose to retain a light and loose treatment, it would take very little to finish the picture at this stage.

Step 4
Going for a more fully rendered approach, I used more washes of watercolor to describe the local tones of the plumage. Compared to the previous step, you can see how heavy this looks.

Step 5
So as to bring life back to the picture, I used white ink and a fine brush to add highlights and brighter accents. In some spots I applied the ink undiluted, elsewhere I diluted it to paint the sheen and texture of the feathers.

27

Toned Paper

There are many advantages to working on gray or colored paper (or "toned grounds"). The tone of the paper gives you a head start with shading, and highlights show up bright and clear. It requires a bit of advance planning to use the tone of the paper effectively, and it's important to select the appropriate shade of paper for your subject.

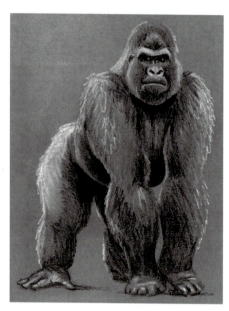

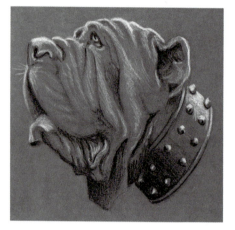

Textures such as fur and feathers are quite easy to describe when drawing light on to dark. This fluffy little fellow came together quite quickly with gray and white pastels, smudged together and detailed with a small amount of charcoal.

I used a very soft pencil for this gorilla, and roughly shaded him following the direction of hair growth. Before I could apply the highlights, I had to erase some of the shiny graphite to allow the white pencil a clear surface to draw on.

To avoid the problem of shiny graphite, I used here gray colored pencils for the underdrawing and rough shading. Then I could use a white pencil quite freely over it to model the dog's wrinkles, reserving the brightest marks for the lighting on top of the head.

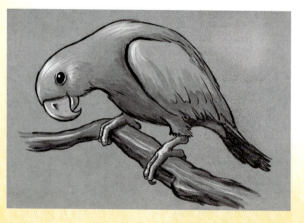

Together with the outline, the tone of the paper does most of the work in this drawing of a parakeet. Shading is just a few strokes of watercolor followed by some soft highlights of diluted white ink.

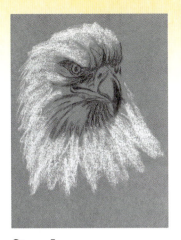

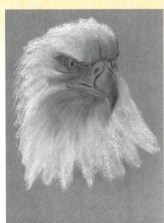

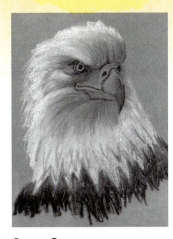

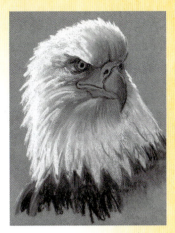

Step 1

I started this drawing by roughly sketching in the features of the face and shadowy parts with charcoal. I roughed in the shape of the head and main areas of light with the side of a short stick of white chalk.

Step 2

With the tip of a finger, I smoothed over the surface and blended the chalk and charcoal together. Already this formed a strong base on to which I could work the detail.

Step 3

Here I used the charcoal again to redefine the drawing and add some textural marks to the feathers. I also brought in a hint of the shoulders to give weight to the picture and shape the neck feathers.

Step 4

Pressing down hard on the point of the chalk made bolder marks to stand out from the smudged underdrawing, just right for the bright highlights down the side and top of the head. You can see here where my sleeve smudged the bottom of the drawing – always a hazard to bear in mind.

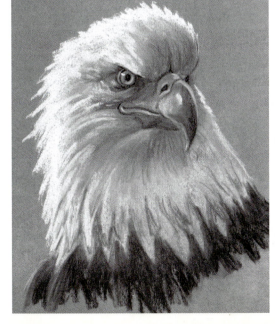

Step 5

A little bit of adjustment here and there and then the fun bit. Adding the detailed highlights on the face gave the drawing a satisfying illusion of shine. Then all that remained was to tidy up any scruffy marks around the edge and give it a spray with fixative.

HANDY HINT

For detailed work, charcoal can be fashioned with a sharp knife. Rather than forming a point like a pencil, charcoal tends to work best when sharpened on one side only, rather like an old-fashioned quill pen. Always point the blade away from the body.

29

Close Observation

Useful as photographs are, there is nothing like drawing from real three-dimensional objects for making clear, detailed observations and sharpening your drawing skills. It is excellent practice to sketch from stuffed animals, such as may be found in many town and city museums. These specimens provide the opportunity for the close study that live animals and photographs can rarely equal. The examples over the following few pages were all drawn on a visit to a local museum.

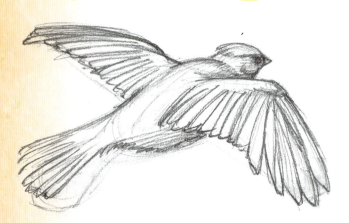

Maybe small details catch your eye, like this opossum's claws. Just as with people, animal hands can lend a great deal of character to their overall portrait so it's worth jotting down such details, which are not always easy to see in photographs.

To draw birds convincingly, the artist should know about the arrangement of their feathers, which is not always clear in photographs. Since most flighted birds have similar feather patterns, studies like this can be referred to for clarifying later drawing difficulties.

HANDY HINT

For sketching away from home I favor a hard-backed, book-bound sketchbook of about A4 size. It is small enough to carry easily, yet opens into a large, well-supported drawing surface.

The heads of big cats are very powerful and expressive. Sketches of their faces will pay off when you come to do finished drawings, and with their strong shapes they are fun to do.

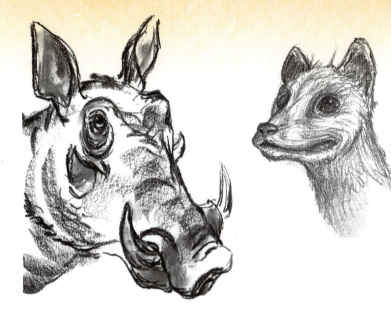

Getting close to a model allows for quite detailed drawings. In this one I wanted to record the direction of the hair growth around the head, which would be useful knowledge for future animal drawings.

I sketched this warthog for no other reason than enjoyment, as it possessed such interesting contours. Charcoal on rough paper seemed the right medium for the coarse leathery texture. I didn't bother with erasing mistakes, but simply smudged them with my finger.

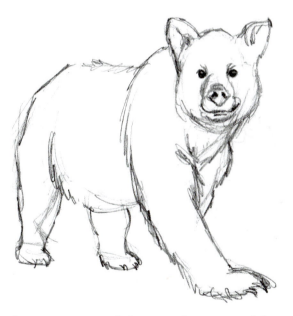

The experience of drawing from a model is very different from working from photographs. Even simple outline sketches like this provide great drawing practice.

The texture of the fur is all-important here, impressionistic rather than closely observed. I drew with a soft graphite stick and then smudged the hair with my finger for that fluffy look. Then I worked into the face with the tip of the stick for contrasting hard-edged and angular marks.

Close Observation

Looking at photographs and illustrations of animals, you'll soon realize how limited the angles of view are. In a museum, I was able to choose my views of this rhino, resulting in an unusual head study and a rear view. In the drawing on the right I tried to capture an impression of the texture, through a combination of mark making and shading.

To draw the heavily textured skin of this tortoise, I used a very soft, blunted pencil, pressing down quite hard around each scale for strong definition. I then shaded over more lightly to show the play of light over the deep relief of the surfaces.

I rapidly drew and shaded these claws in HB pencil, then applied more considered textural marks and outlines with a drawing pen. This is a quick way to get a textural feeling into a sketch.

In a dim display case, most of this crow was little more than a silhouette, except where the head and shoulders caught the light. I drew it roughly in pencil, marking the direction of plumage, and then drew around the highlights and outlines in drawing pen. I recorded enough detail to enable me to finish the picture later.

The sharp line of a drawing pen was a good choice of medium for these spiky feathers. I used pencil to establish the general shape and then drew the detail directly with the pen, making my marks deliberately harsh and jagged where appropriate.

Back at home, I erased the pencil marks and then blocked in the solid black with brush and ink. A drawing doesn't need much textural mark making to convincingly suggest the texture of the whole.

HANDY HINT

Visit museums at quiet times if possible, otherwise you may be interrupted or create an obstacle to others. You may need to obtain permission to draw before you start.

33

Drawing from Life

Drawing from stuffed models is good preparation for facing one of the great challenges — live animals. It is useful to adopt the right mindset. The practice is usually limited to gleaning impressions, familiarity and information about your subjects, rather than making finished pictures in one sitting. Think of your sketchbook as a personal journal that nobody else ever need see, a space in which to gather information, and also to make errors and false starts and chart your artistic development.

If an animal is tired or bored, it's unlikely to move too much, but make sure that your drawing activity doesn't excite its interest. I sketched the bulldog on the far left at a dog show, late in the day after it had been waiting around for hours. The labrador was a young guide dog, selected for its calm temperament. It lay on a café floor and didn't move a muscle while I drew.

Erratic though they may be, there are many circumstances in which animals may remain relatively static and give you a good introduction to drawing from life. But even sedate creatures will not remain still for long, so it requires quick responses and a willingness to abandon drawings when the model ceases to cooperate.

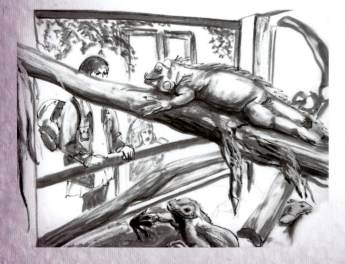

In a zoo, the animals will often sit motionless for long periods. For drawing the iguana enclosure I used a permanent ink brush pen and watered-down ink applied with a broad bristle brush. The parrots were drawn very quickly with charcoal. I then scrubbed on some water-soluble crayon and blended the tones with brush and water.

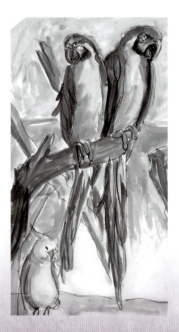

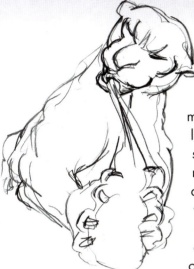

Food is always good for keeping animals in one place. I observed this lioness vigorously tugging at some meat, then drew most of the picture without looking up. With the basic shape in place, I could then refer to the moving animal and glean enough information to add details. It's not an accurate drawing, but it does have something of the creature's attitude.

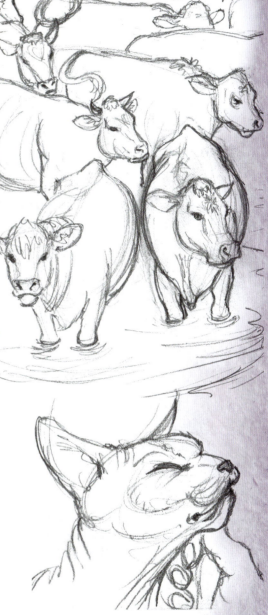

On a hot day, these cows stood for a long time in a pond to keep cool. I attempted to draw them as a scene, roughly drawing the foreground animals first and working backward, filling in the gaps. The cows' heads moved a lot and I had to keep turning my attention from one to another.

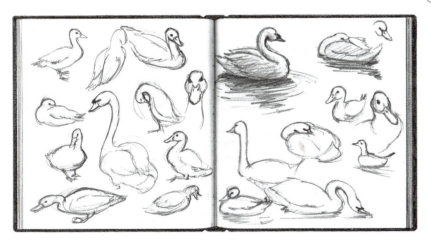

Water birds won't remain static, making close study difficult. A good way to draw them is to work on several pictures at the same time. As one bird moves, abandon the drawing and work on another. Soon another bird will adopt a similar position for long enough for you to complete the first sketch.

An excitable pet can often be made to sit still for a short time if it is stroked and petted.

Drawing from Life

The level of difficulty involved in drawing animals that are behaving naturally is determined by your choice of subject. Even a really experienced and dedicated wildlife artist would gain little from brief glimpses of shy creatures scuttling among the undergrowth. Try to find subjects that are visible in numbers and comfortable with people. For these reasons, I found the livestock at a local alpaca farm ideal to work from.

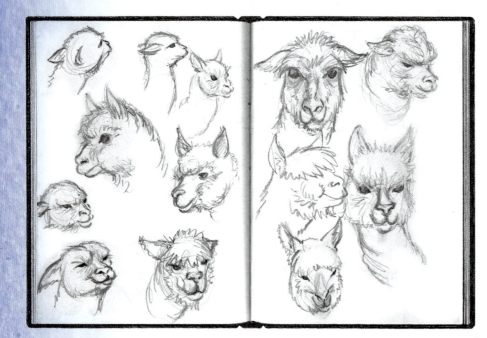

Naturally inquisitive, the alpacas were intrigued by my presence and gathered around me in the field, allowing me to make these quick portrait studies of the individual animals.

Once the alpacas had gotten bored with me I aimed to set down some of the natural poses adopted by the animals as they grazed and lazed around. I had to keep on my feet and move around to follow their movements. The more rapid sketches here are of the younger animals – characterful in form but very lively.

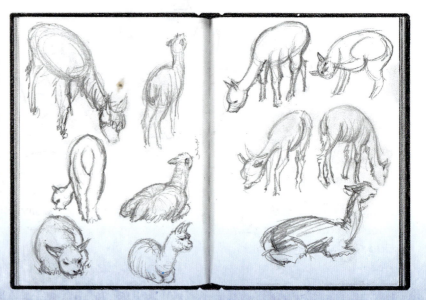

Drawing in the field it's best to limit your aims to capturing the bare essence of an animal, its general form and posture or any odd details that you may notice. If you glean enough information, you may be able to work up some of your drawings into more accomplished studies later.

SCRIBBLING
Step 1
From a very close viewpoint, I very quickly roughed out this basic sketch scribbling with the side of the pencil.

Step 2
Back at home, with the alpacas still fresh in my mind, I cleaned up this drawing and, referring to my other sketches, added some more detailed characterization.

SPIRAL
Step 1
This is a good way of producing quick, lively sketches. Keeping the pencil on the paper, I moved it in continuous spiral patterns, searching for form as I looked back and forth from subject to paper. The result has a definite three-dimensional quality.

Step 2
Using a water-soluble pencil as my default sketching tool gives me the option to add further tone very easily if it is called for. To work up this sketch, I merely applied clean water with a brush and, when dry, added a few details with the pencil and cleaned up the edges with an eraser.

37

Motion and Dynamism

It is not always easy to capture a sense of movement in animal drawings, and reference to photographs is particularly helpful in this field. It also helps to observe animals in motion, in real life or on screen to gain an understanding of the characteristic actions of certain species. You can also bring dynamism to your drawings by considered use of poses, viewpoints and exaggeration.

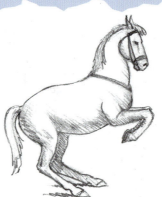

Despite the strength and control required to hold this position, this circus horse is in a state of balance and the implied motion is minimal.

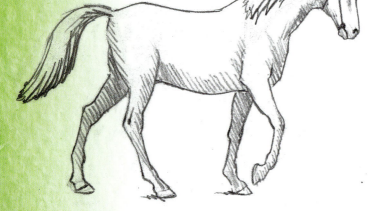

The mere raising of a foot is enough to suggest motion, but there's clearly no hurry or drama involved here.

Knowing that horses cannot maintain poses like this, a sense of forward motion is clear to the viewer. The raised legs, forward leaning, neck tension and flowing tail all add to the effect.

This horse is probably traveling no faster than the walking horse above, but the forward leaning angle and tension in the neck suggest an activity of considerable force.

Here the carefully modelled muscular tension is sufficient to convey dramatic motion even though the horse's body is not shown. The free-flowing mane suggests that it is moving forward at speed.

Placing the viewer in the path of the action also helps to create dramatic pictures.

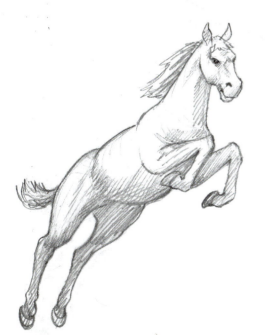

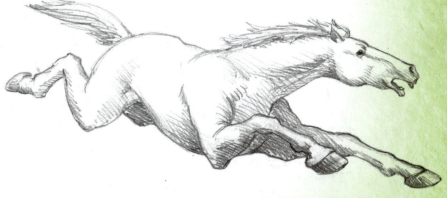

The action here is exaggerated by the low viewpoint. Looking up at a subject usually has the effect of conveying power.

This drawing is contrived for maximum dramatic impact. Though the pose is entirely unnatural, the proportions and details are realistic enough to coerce the viewer into going along with the deceit.

Character and Expression

As well as the great diversity of species, individuals within a species often display their own particular traits and features. Getting to know pets, we soon notice their particular characteristics, certain expressions and funny little ways. Capturing a "portrait" of a specific animal can be a subtle, yet rewarding challenge.

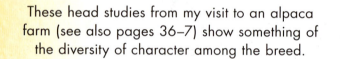

These head studies from my visit to an alpaca farm (see also pages 36–7) show something of the diversity of character among the breed.

Time spent studying an individual animal – such as this spaniel – pays dividends. With each new drawing you will notice some extra little detail or quirk.

It is hard to resist reading human qualities into many animals' faces. As with portraits of people, it takes close observation to capture a likeness or particular expression.

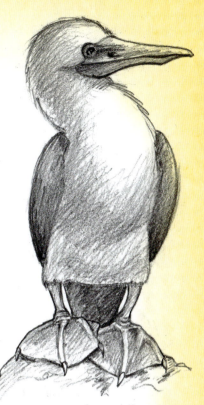

To accentuate the mildly comic appeal of this booby, I emphasized the curve of its neck and enlarged the feet. This sort of subtle caricature can give your drawings extra character and impact.

Generations of selective breeding have made this bloodhound into a living caricature. But still there is scope for the artist to exaggerate its features further, though in this case it strays into cartoon territory. The more you understand about how animals should look, the more freedom you will have to exploit their characteristics for artistic effects such as drama, grandeur and comedy.

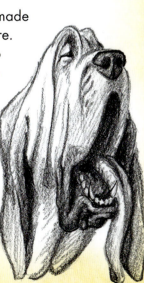

Stylization

Most of our drawings so far have been fairly naturalistic in their aim. However, animals also offer the artist enormous scope for interpretation. Experimenting with treatment, simplification, caricature and designerly qualities is not only enjoyable, but it can also contribute to developing your own personal drawing language, or "style."

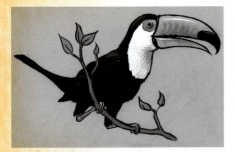

Stripping away unnecessary detail can produce pleasing results. This toucan is drawn in solid black ink, with a few touches of watercolor and white ink.

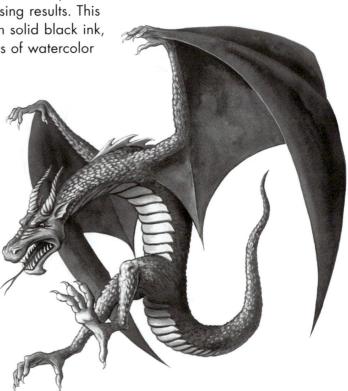

This fairly realistic depiction involved a lot of painstaking blending of watercolor washes. It's competent enough but there is not much of a personal touch in evidence.

A similarly detailed treatment, but here I got to design the creature. It's a rewarding challenge to come up with a fantasy creature that is credible. The secret is to refer to real animals for inspiration, in this case bats, birds and reptiles.

This cheetah is drawn in a very simple, spare style. For visual interest, the felt-tip outline is varied in width and the detail is allowed to fade out toward the rear.

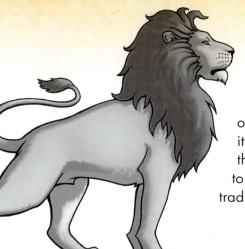

Using a computer to render this outline drawing lends it a graphic slickness that would be hard to achieve with traditional media.

Animals interacting within a scene implies a sense of narrative, which is further enhanced when they are endowed with human expressions.

The same medium is here used to greater dramatic effect through exaggeration of the lion's physique, stance and expression.

In these two drawings, the human qualities are reinforced with the addition of clothing. In such depictions, I always try to retain a strong sense of the animal's own characteristics.

43

Cartooning

With their interesting shapes and charming qualities, animals naturally lend themselves to the art of cartooning. This seemingly simple discipline involves skills of exaggeration, simplification, design and, in many cases, a good grasp of anatomy. At the heart of transforming animals into cartoon drawings is the concept of "anthropomorphism," conveying human traits and expressions.

Some standard body shapes are often used as starting points for cartoons and shortcuts to personality types. These are usually based around the basic pear shape for the body and a circle or oval for the head. The proportions of these shapes determine the final character.

This bear, with dramatically enlarged head, shoulders and forelegs is typical of fierce and powerful beasts such as bulls, gorillas and big cats. The fox here represents the wily wise-guy type and the squirrel, with his round shoulders and potbelly, follows a standard "dopey" design. These basic shapes can be applied to most animals, whatever their natural forms.

The proportions of this horse remain generally naturalistic, but the form is simplified and streamlined. The enlarged eyes and mouth make the animal appealing and also flexible enough for human facial expressions.

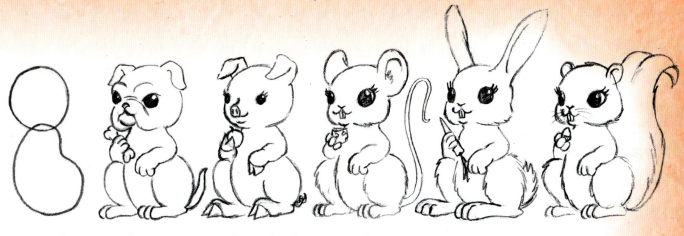

The "cute" character type reflects the features and proportions of a human baby. The same body shape can be used to design virtually any creature by merely changing the features and details.

Animals may also be designed by their natural body types. This pig is basically a big oval, while the cheetah is made extra lean and its natural curves exaggerated. Their faces also contribute much to the characterization.

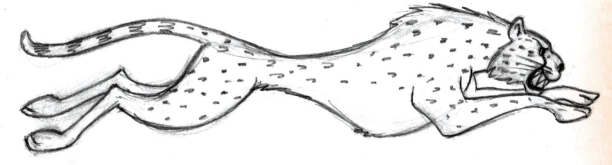

Within established cartooning conventions there is limitless scope for character design. Here are just a few variations on a cat in "cute" proportions.

Glossary

abstract A painting or sculpture that does not depict a person, place or something in the natural world.

accent To highlight a particular part of a picture so it attracts more attention.

amphibian A type of animal that spends part of its life on land and part in water.

articulation Joints that allow movement.

caricature A funny drawing that exaggerates some of a person's features.

characterization The way in which a character is shown.

charcoal A black substance made from wood that is used for drawing.

contour The outline of a shape or form.

draftsmanship Skill in making drawings.

dry brush A painting technique in which paint is put on a dry brush and gives a scratchy effect when applied.

dynamism The appearance of movement or activity.

embellishment Details to make something look nicer.

exaggeration Making something seem much bigger, smaller, better, worse, etc. than it really is.

felt-tipped brush pen Felt-tipped pens with a flexible brush point on one side and a fine point on the other.

fixative A spray that stops artwork from smudging.

form The elements of a piece and how they fit together in a piece of artwork.

graphite A soft, black material used to make pencils.

highlight The area of the lightest tone in a drawing.

mark To make any of the lines or textures in an artwork.

muscularity The state of being muscular.

pastel Soft, colored chalk, for drawing.

primate The mammal order that includes monkeys, apes and humans.

profile The outline of a face when you look from the side.

proportion The relationship of one thing to another, for example, the features in a face.

quadruped An animal that has four feet.

rendering Shading.

silhouette The dark outline of a person or animal that you see against a light background.

simplification Making something simpler.

streamlined With a smooth, even shape.

stylization When an image does not look real, it is stylized.

tone The shade of a color.

underdrawing The first drawing for an illustration that is then drawn over.

versatility Having many different uses.

wash A fine layer of color that is evenly spread with a brush over a broad surface.

watercolor Paint that you mix with water.

For Further Reading

BOOKS

The Artist's Guide to Drawing Realistic Animals by Doug Lindstrand (North Light Books, 2006).

The Beginner's Guide to Drawing Animals, Bugs, Dinosaurs and Other Cool Stuff (Sketch It!) by Amy Bailey Muehlenhardt (Capstone Press, 2010).

Cartoon Cute Animals: How to Draw the Most Irresistible Creatures on the Planet by Christopher Hart (Watson-Guptill, 2010).

Draw Baby Animals by Jane Maday (North Light Books, 2009).

Ed Emberley's Drawing Book of Animals by Ed Emberley (LB Kids, 2006).

How to Draw 101 Pets (How to Draw) by Dan Green (Top That! Kids, 2008).

How to Draw Dolphins & Other Sea Animals (How to Draw) by Dan Green (Top That! Kids, 2008).

Kids Draw Animals by Christopher Hart (Paw Prints, 2008).

You Can Draw Cartoon Animals: A Simple Step-by-step Drawing Guide! (Just for Kids!) by Christopher Hart, 2009).

WEB SITES

Due to the changing nature of Internet links, Rosen Publishing has developed an online list of Web sites related to the subject of this book. This site is updated regularly. Please use this link to access the list:

http://www.rosenlinks.com/draw/ani

Index